HERMÈS
heavenly days

HERMÈS

heavenly days

by

Alice Charbin

and Rachael Canepari

Abrams, New York

TABLE OF CONTENTS

Journey to Alice's World 7

Pierre-Alexis Dumas

What Madame Paquita sees 9

Valérie Mréjen

Hermès: you have mail! 13

A beautiful beginning —14 Autumn colours —31
Happy Halloween —46 All together for Thanksgiving —57
Merry Christmas! —67 Winter games —98
Special wishes —106 Saint Valentine's lovebirds —116
Spring cleaning —132 Saint Patrick's Day —142
April Fools —151 Easter eggs —152 Happy Mother's Day —164
Happy Father's Day —188 Celebration days —210
Sunny days —216 Pack your bags! —226

How it all began 249

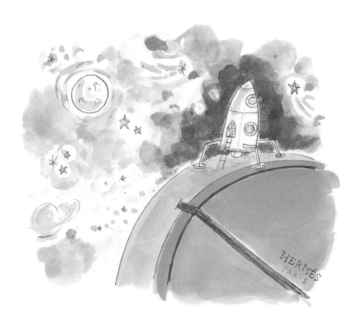

MISSION HERMÈS, SUMMER 2013.

My dear Alice, what genius moves your pencil? I followed your instructions and here I am, on the moon. I feel at home on this satellite. I'm preparing to explore it with the excitement of a child who understands at once that he's in the hands of a master, an unrivaled spinner of tall tales... From here, the greyness of everyday life seems far away. Your line—supple and spirited, a tad theatrical—sets the tone with an effective and disarming simplicity.

With your mischievous gaze, you transform every idea into a pumpkin, and every pumpkin into an enchanted object that sweeps me away with delight! There really is an *Alice's wonderland*—your world. An invitation to return to the spellbound state of childhood, where nothing is taken for granted and everything is new, exhilarating and brimming with surprises. An invitation to see through the eyes of a playful bon vivant. An invitation to happiness.

Your love of life is contagious! And what if paradise were here on Earth, in all the wonders that surround us and that we don't see? This is where your talent lies: In showing us the beauty in all that is simple, spontaneous, joyful, and poetic. In opening our eyes to intangible moments with humor and a light touch. In stealing our hearts with a stroke of your pencil. These aren't just drawings, but a life's work.

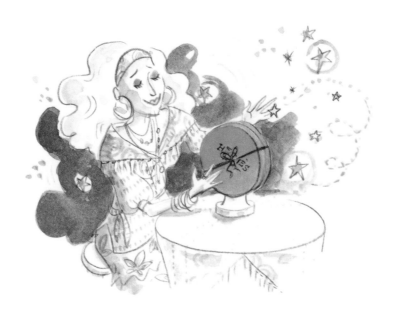

CRYSTAL CLEAR, NEW YEAR 2008.

I see, says Madame Paquita, glimmers of orange, the dominant color in an ethereal world where, as if by magic, your ironing board or the sausages you're turning on the grill might suddenly transform into Hermès boxes containing gifts that will not necessarily be an ironing board or sausages. These new things will be altogether different, and better. You won't be able to use them in the same way as before, but you'll gain much more than you lose in the exchange. There will be an element of surprise, a reversal of the situation: the phone you were holding to your ear in the middle of a crucial conversation, the covered wagon in which you were carrying your modest possessions through the desert, or the traditional bûche de Noël you were preparing to slice as your impatient children looked on might turn into cufflinks or a little cylinder-shaped purse.

In my cardboard ball, Madame Paquita continues, I see that you claim not to believe in magical beings, such as Santa Claus. I understand–you're probably afraid of being teased, and that's completely normal. But between you and me, it's okay to admit it; you know as well as I do that he exists. Since you've had the great privilege of meeting him, you also know that he's a timid, somewhat solitary man

who's remained approachable and humble at heart. It's hard to believe that someone so famous leads, in reality, an almost quiet life, that he buys his own groceries and does his own ironing, drives his own sleigh instead of hiring a chauffeur and even repairs its engine himself. It's astonishing to think that a superhero like him would go to the barber every now and then to keep his curls and his long beard looking nice, or that he'd take advantage of the idle time to read silly magazines (and find some of the articles—yes, just like you and me—rather interesting).

In my crystal ball, I see horses balancing piles of gifts on their backs, couples in love, a snake charmer, a number of vacationers, a dapper-looking squirrel, several types of flying vehicles. I see a fish that's square and orange, but not frozen. I see birds' nests and top hats, a sandcastle and an enchanted mirror, a planet, a rocket, hand cymbals, a bass drum, swings, a flat screen. A bear sleeping in its cave, and blazing maples in autumn.

A thread drawn in graphite connects these images. I see the stroke of a pencil that grants these boxes a new purpose, that draws the contours of a universe filled with boxes. Boxes in which we might find longed-for items, boxes whose contents might fulfill our wildest dreams.

I see a woman who has the power to transform anything she wants into orange boxes, and scatters these fanciful apparitions all over the world. She uses watercolors and crayons, keeping an entire drawer stocked with supplies in her favorite color, since she uses quite a lot of it.

All the while, a correspondent in Nice–whose name must be Rachael, according to my expert verifications–sorts the information as it comes in and writes captions to accompany these scenes that appear to her, scenes as marvellous as they are unexpected. She remains in direct contact by telepathy in order to communicate the necessary details: context, setting, and the identity of the lucky subjects.

I think I'm getting a glimpse of our artist, who pulls a pumpkin pie from the oven and pours herself a glass of carrot juice before returning to her drawings. In the garden, a string of Chinese lanterns. A sublime sunset. A large family gathered around a table*, her source of inspiration.

* *among the children seated there, I believe I can make out a few heads of fiery orange hair.*

Hermès : You have mail !

The drawings featured in this book were created
for subscribers to the Hermès online store.
Accompanied by lively text, they feature an orange box in different
guises, celebrating events throughout the calendar year.

On some pages the box simply disappears,
leaving behind its very essence. With a touch of magic, a simple
black line is brought to life by the colour orange!

MORE OF THE STORY BEHIND THESE DRAWINGS
ON PAGE 249

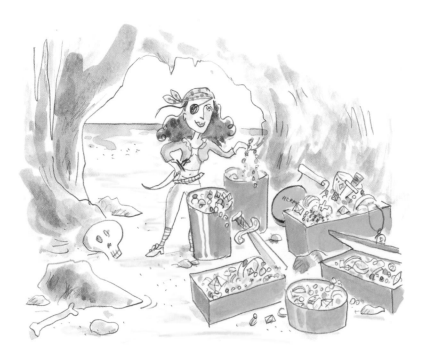

There is a treasure trove of gold to discover.

For the perfect accessory to a fashionable outlaw.

Pirate Pete's patch adds panache
and pizzazz.

Raymond relishes rainy days - Yes, really!

Everyone has bags of attitude.

To a well-heeled gathering.

spot on!!

Harold's hankering for a hole in one
to halve his handicap - Hopeful!

Home is the best.

The start of a beautiful story

All dressed up for the oktoberfest!

Royale relishes rhyming rap
on the radio - Right on!

Pamela's pedigrees are profoundly
pampered pets - Precious!

And it's perfect!

Always have something new up your sleeve.

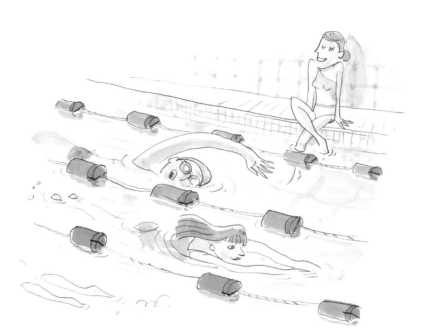

It's all in the technique.

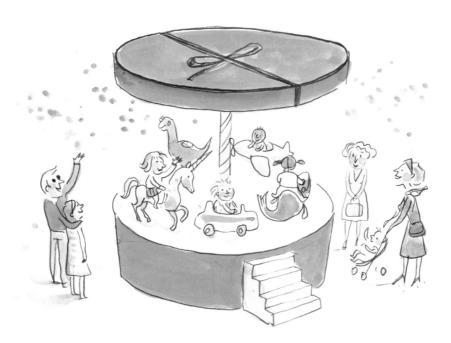

Celebrate the turn of the seasons
with a turn in the park.

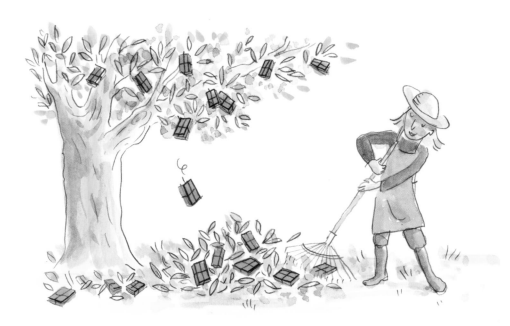

Fall tasks bring unexpected windfalls.

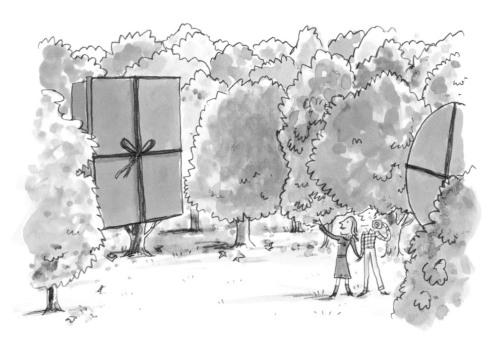

The splendour of autumn's gifts.

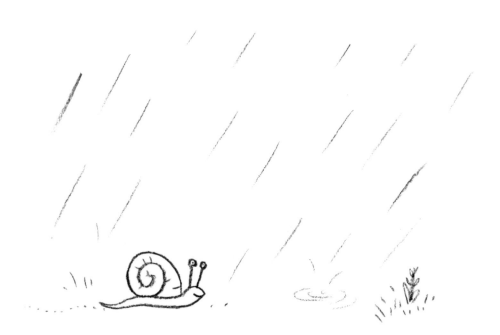

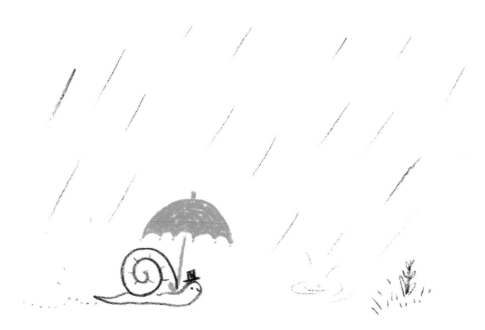

Raindrops keep falling on my head.

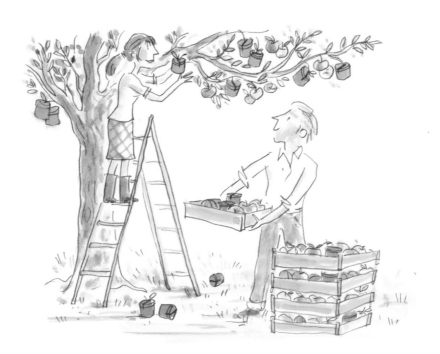

Enjoy autumn's harvest

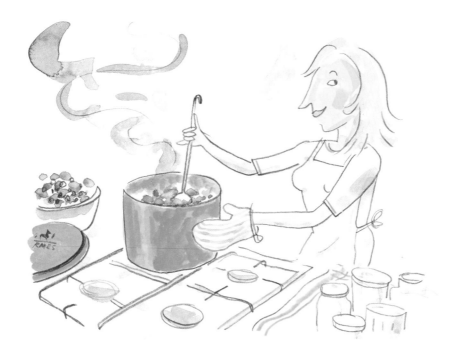

Jenny's jams are jellied jewels - Jackpot!

Autumn treasures make rich pickings for breakfast.

very sweet dreams.

Enjoying the bright spot of a blustery autumnal day.

Make for a charmed life.

Let sleeping dogs lie comfortably.

Stanley's secret stash of supplies is scrumptious!

Teddy and Tara tuck into tempting tea
toast and teacakes - Tasty!

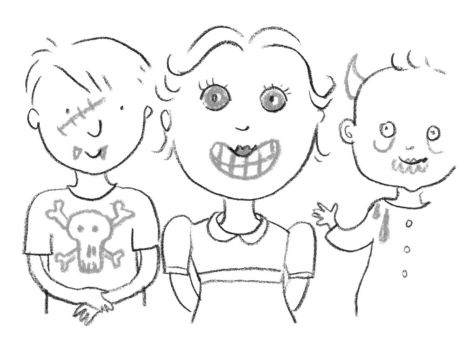

Frightfully delightful.

Clare's in costume concocting crazy cocktails
in her cauldron.

Get into the spirit of things.

Just the recipe for a perfect Halloween.

This Halloween, have a ball (and chain!).

To Hallow-scream!!!

Halloween, something to sink your teeth into.

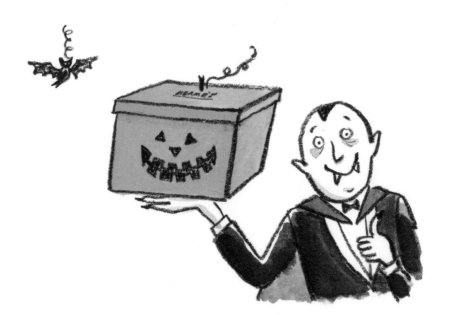

Sam's squash is sensationally
sculptured - Sorcerous!

Taka's telephoning from Tokyo, to get together
with Tina this Thanksgiving - Terrific!

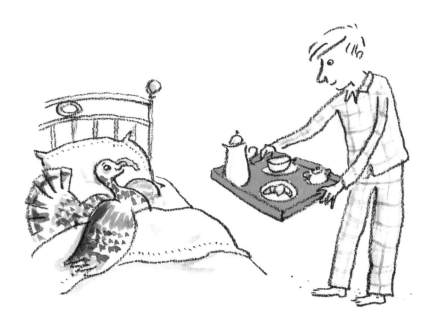

Tom's turkey's the trusting type - Too bad!

Affirmative!!

Philip has a penchant
for Patty's pumpkin pie - Paradise!

A toast to turkeys at the Thanksgiving table -
Tremendously tasty!

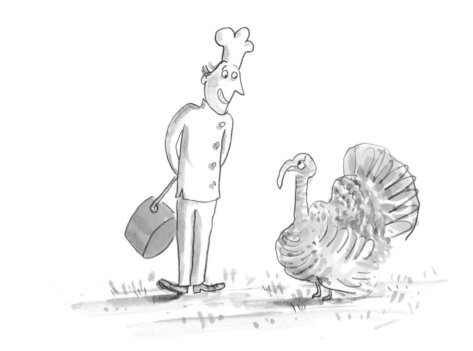

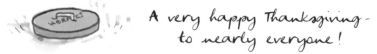

A very happy Thanksgiving -
to nearly everyone!

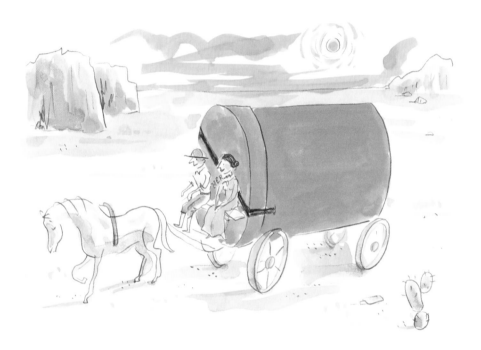

Travel in style at Thanksgiving!

Thanksgiving dinner, a slice of family life.

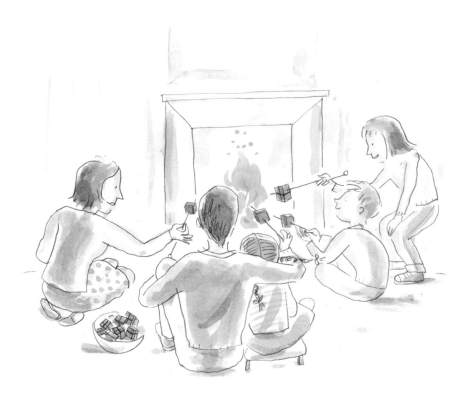

Mouthfuls of melting mashmallows.
Mmmmm!

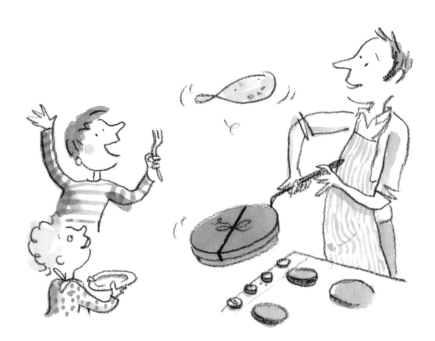

Tim's truly talented at tossing
tasty Thanksgiving treats.

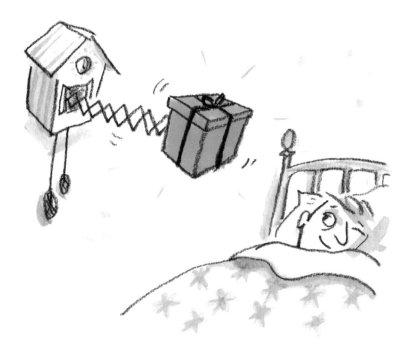

Alfred's awoken by an awfully
amazing alarm - Awesome!

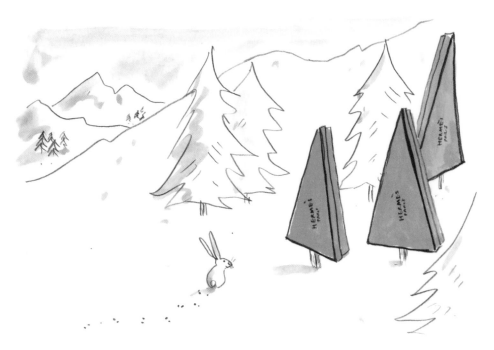

Add colour to a white Christmas.

Sounds of sweet singing in the streets
stir the spirits - Splendid!

All the ingredients for festive fun.

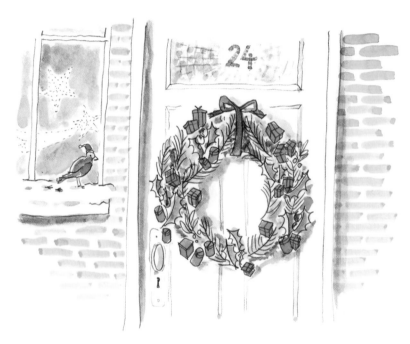

Dee's delightfully decorated door - Divine!

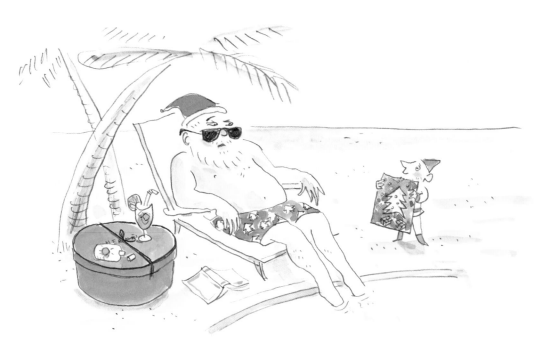

Christmas is on its way!

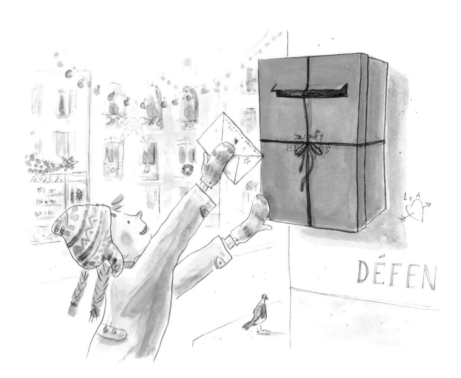

For very happy holidays.

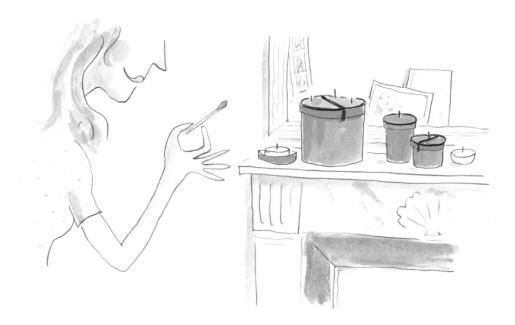

Lighten upon divine candles.

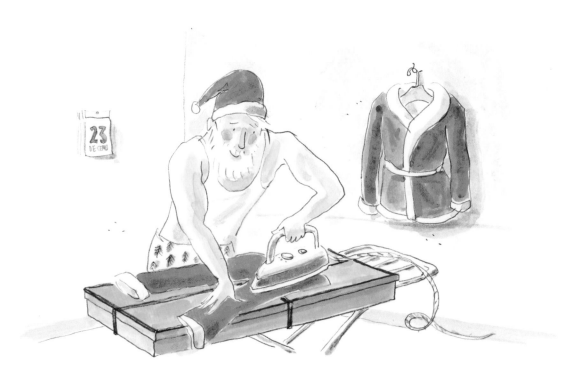

Iron out those last minute present problems.

Keep Santa posted!

Santa's sleigh's swiftly speeding through
the sky - Season's greetings!

Breanna's baskets brim with breathtakingly
beautiful buys. Brilliant!

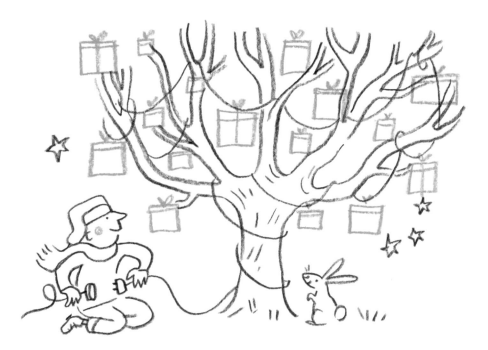

Get prepared for a simply brilliant Christmas!

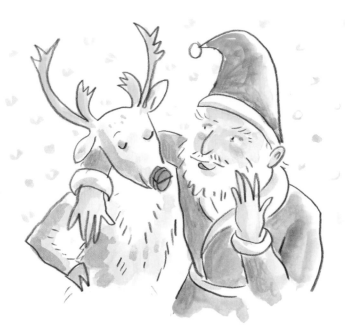

Santa shares a seasonal secret - shh!

Help's at hand, Hector's here.
Happy holidays!

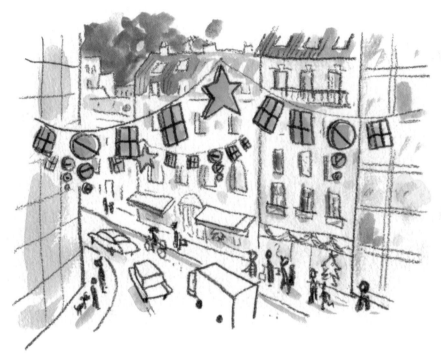

Seasonal stars scintillate in the streets.
Super sparkly!

Santa's stylist sought a smarter style
this season- Snazzy!

Father Christmas's fabricated
a fabulously festive façade - Fantastic!

Speedy solutions from a supersonic
Santa - Super service!

Keep things running smoothly.

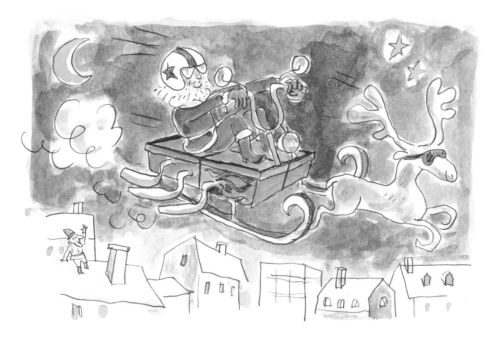

Get things off to a flying start.

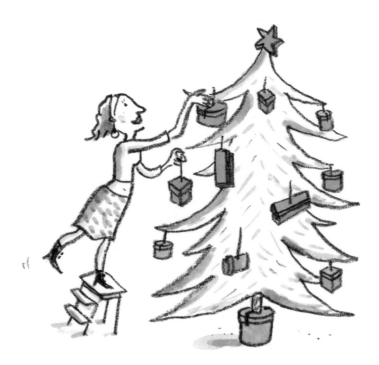

Daphne's decorations are dazzlingly deluxe.
Divine!

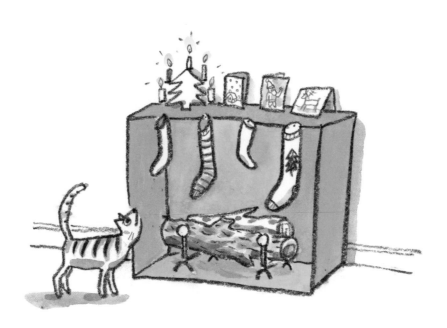

Santa Claus considers a cardboard chimney
a cooler course of conveyance - of course!

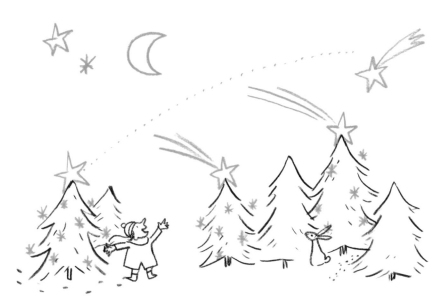

Put the sparkle into Christmas!

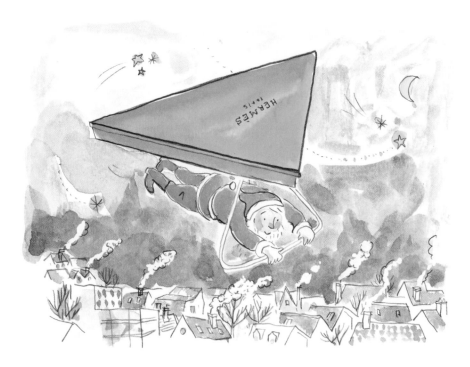

Christmas is in the air.

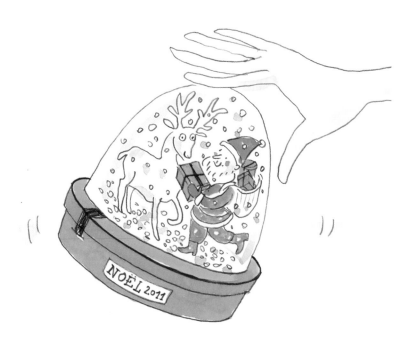

shake things up this Christmas!

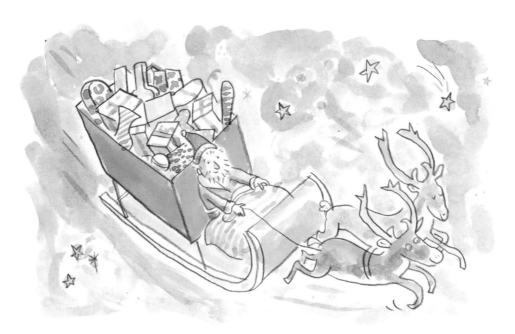

Soon Santa will surf the sky, stuffing stockings with surprises- Seasons greetings!

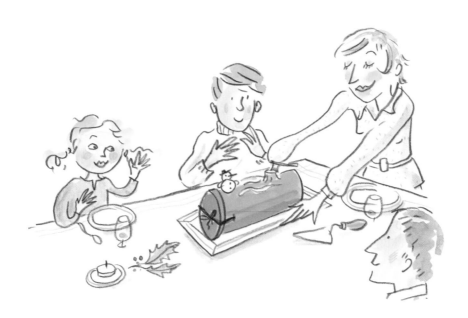

It's a piece of cake!

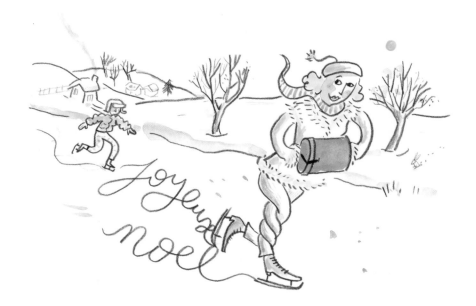

Isabel's an imaginative and innovative
ice skater- Indeed!

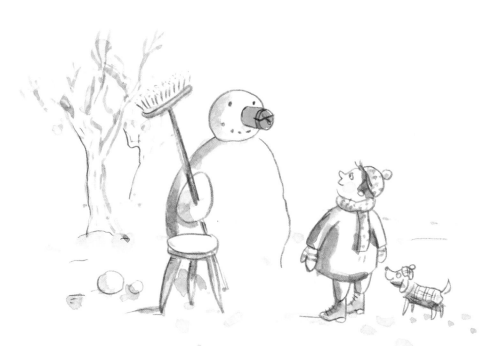

Freddy gives Frosty's festive finery
a finishing touch - Fabulous!

Martin moves like a meteor
in the mountains- Magic!

Sporty Sebastian slides down
the slopes with style - Speedy!

It's as plain as the nose on your face.

Freestyle in style!

Sledding with style, swooping through snow with speed - Strong sensations!

Here's news to get steamed up about.

Bringing colour to white winter days!

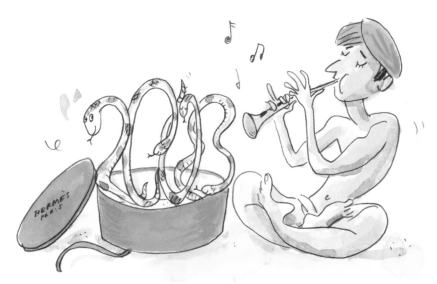

serpents slither to spell in spectacular style.

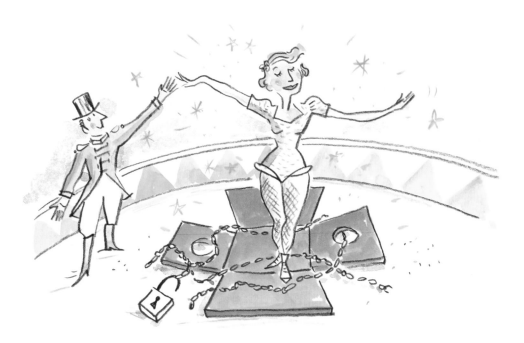

Ella escapes with ease and elegance -
Extraordinary!

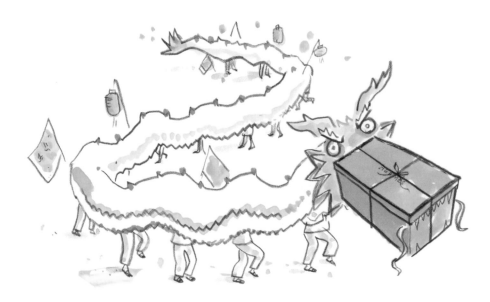

Divinely decorated dragons dance by.
Dashing and dramatic.

Felix is feeling far from flat in his
fancy footwear - Feverish!

A winning combination.

There's magic in the air!

Tina's totally transformed
by the tempestuous tempo - Terrific!

Princess is partial to being primped
and preened. A pedigree pooch!

I give you my hearts!

sweethearts smooch in the spring- sweet!

Adrian's attracted to aerobatics
and Annie - Adorable!

Sarah and Stewart are smooching in the snow
- what a smacker!

Theresa trembles as Tony tinkles tunes
with tenderness - True love!

Linda loves listening to long love songs
with Luke - That's love!

You're the only fish in the sea for me!

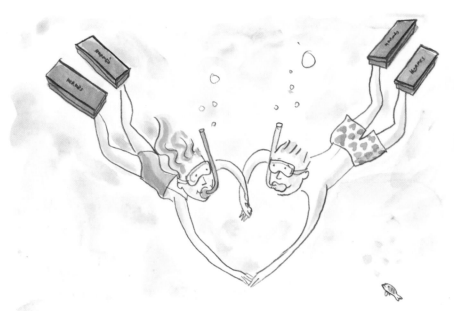

when words are impossible.

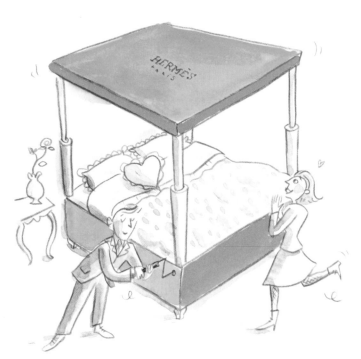

It's St. Valentine's day!

You make me light up inside.

Refresh your senses with something new!

Actions speak louder than words.

Dare to be different?

Tails of the heart.

Gillian grows gold in her garden- Glorious!

The season's in full swing.

Transform yourself!

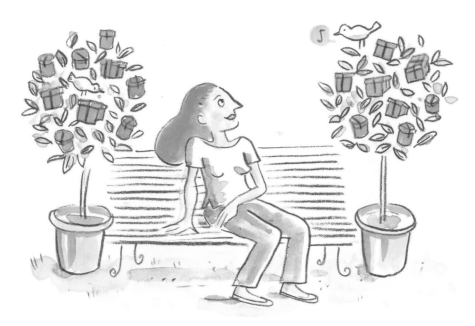

Sit back and enjoy the songs of spring.

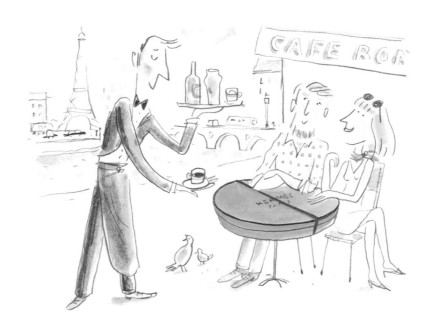

A toast to Paris in the spring.

Have a field day, spring's here.

You could say we're painting the town orange.

That's winter done and dusted.

something worth making a song
and dance about!

Get ready to shamrock n' roll

Sean's sheep swiftly shear the sweet
smelling shamrocks short - Scrumptious!

Ewan's embracing Earth Day with energy and enthusiasm -
an ecological example to us all!

Norah needed a nursery for her
numerous newborn - Neat!

Bob has used his boxes for bulbs - Brilliant!

Children that are as good as gold(fish).

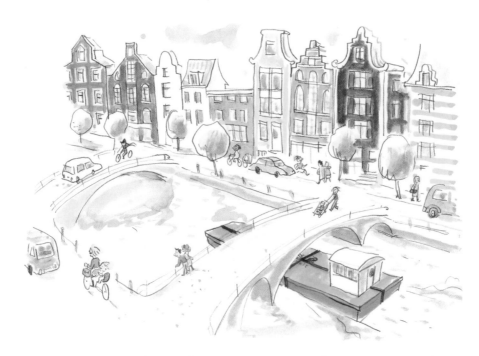

We are pleased to announce the opening of
our Amsterdam store!

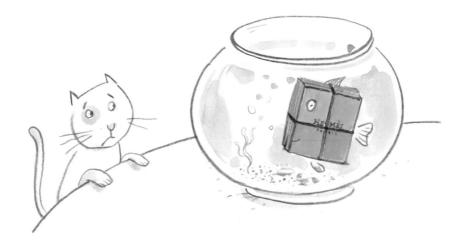

It's neither fish nor fowl but it's got style!

A very generous nest egg.

Better than chocolate.

waiting for a bite... of chocolate.

Chocolate and orange. A delicious combination!

Ahead of time or fashionally late?

Dawn definitely dares to be different.

orange or chocolate?

There are good eggs and bad eggs!

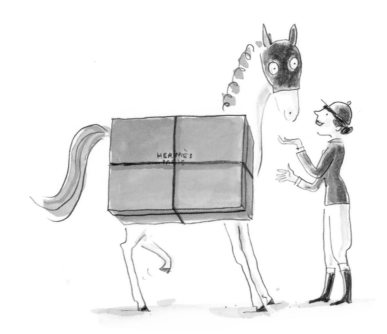

Delicious treats for the perfectly groomed.

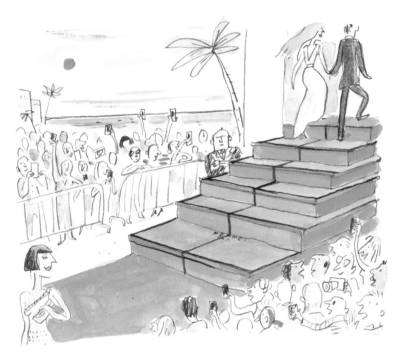

Lights, camera, and action!

Mabel's a majestic mum to a million - Mega!

Miranda marvels misty eyed at Max's
moving Mother's Day message - My boy!

start building your fabulous collection.

Claire's cherubs clutch their cheerful
colourful creations- Charming!

For your queen of hearts.

Getting into hot water
has never been so tempting.

Mum, you're blooming lovely.

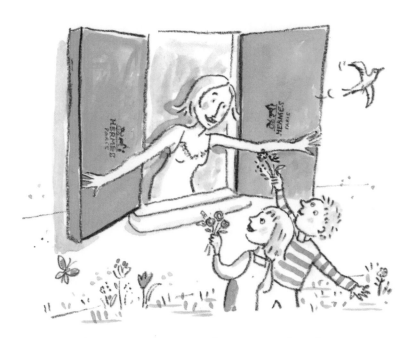

Molly and Mike make their mother's morning magical with marigolds- Mummy!

Marvelous mothers merit more than
mere metal - Magic!

Mirror, mirror on the wall.

Mothers, more than just
a pretty face.

Love that polish, love our mum.

Pampering and indulgence
are the order of the day.

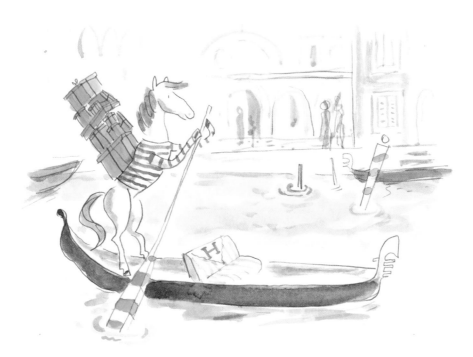

Bringing our online store to Italy!

For prize winning parents!

Take time to refresh your memory.

something for shoe cream buffs!

striking pieces.

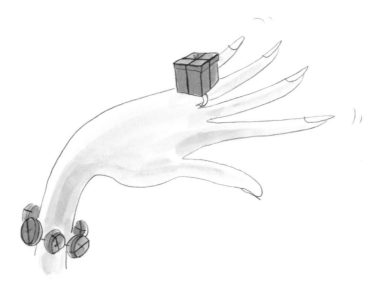

Make a lifetime commitment to silver jewelry.

Flawless as ever.

unique + Extraordinary elements = petit h

Petit h flexes its muscles

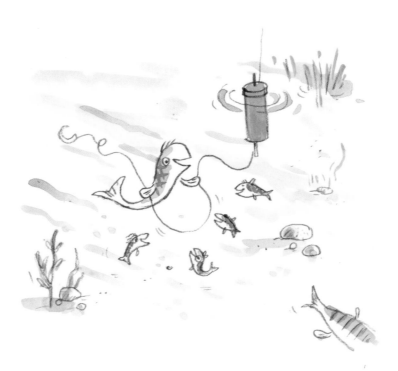

Fergal, Fergus, Fiona, and Fingal's father is fearless and full of fun. A first-class father!

A brilliant addition to your shirt.

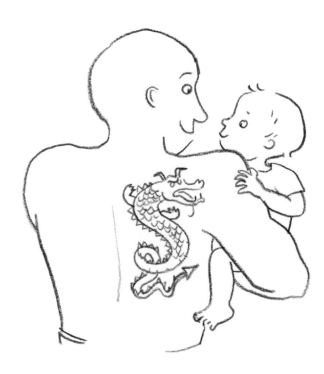

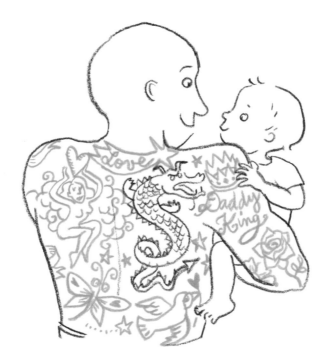

Love that's more than skin deep.

Sidney surfs the slip stream
with style - Sensational!

The famous Federico's flabbergasting
feats of force - Fantastic!

onlookers observe Oscar's offspring
orderly and organized- An ovation please!

Much deserved cheers and applause
for fathers everywhere.

All the accessories for a perfect Father's Day.

Frank has fabricated a flatscreen
for his father - Fabulous!

Poppy, Peter, Pauline, Petra, and Philip proffer
presents to their Papa- Peachy!

Not all knots are equal!

All the right tools to construct
a wonderful day for your Dad.

A helping hand for Dad.

Top of the Pops, Dad rocks!

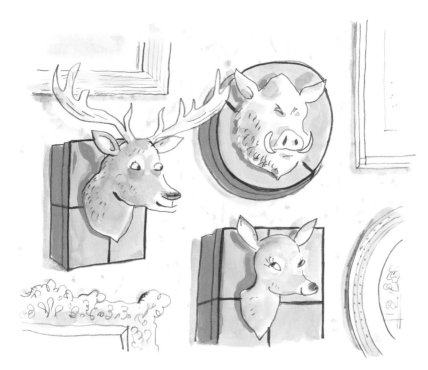

Keep your head this Father's Day.

Dave's a devoted Dad and Damien's
a daredevil - A dashing duo!

Here's the catch of the day.

... and if the contents of your orange box
aren't just right?

Graham's a genius at this game - Great!

Take liberties with silk !

stand tall today!

Bang the drum for summer.

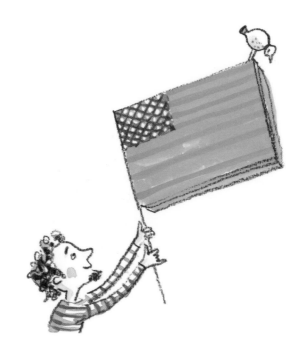

Fran's flying the flag on the fourth –
First rate!

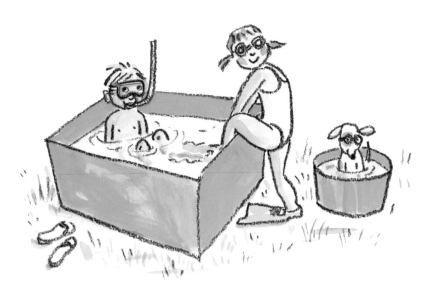

Polly, Paul, and puppy paddle
and play in the pool. Plenty of pranks!

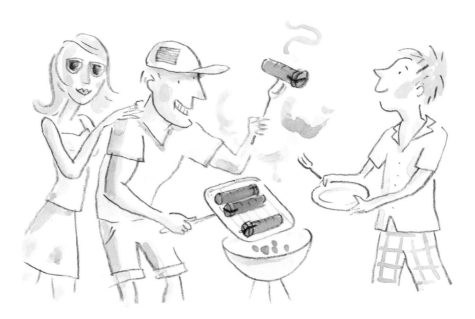

Ian's invitation to indulge on
Independence Day is irresistible.

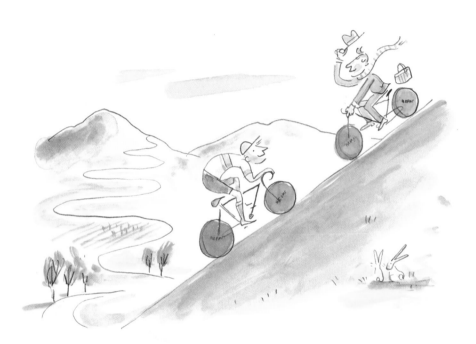

A smooth ride through the ups and downs of life.

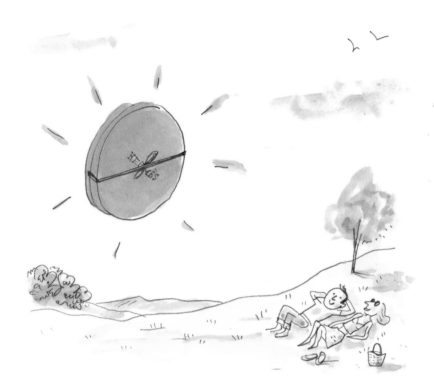

sleepy days stretched out in the sun.

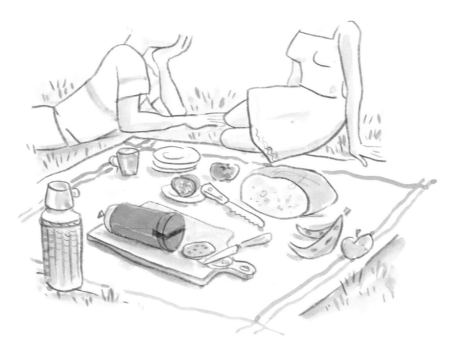

Paul's prepared a prestigious picnic
and he's proud of it.

Dishes that make your mouth water.

Make each meal a work of art.

Jump for joy - Australia's online!

Hats off to our new Brisbane store!

show your true colours this summer!

Live a colourful life!

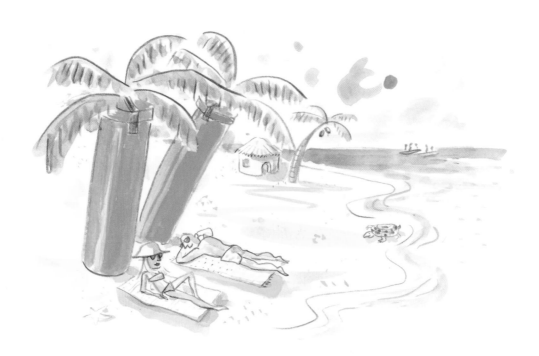

Siestas in the shade on sandy shores -
A simply sublime summer!

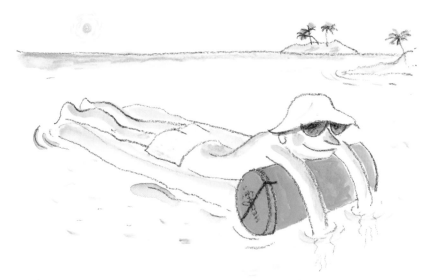

Clive's content to concentrate on chilling out - Cool!

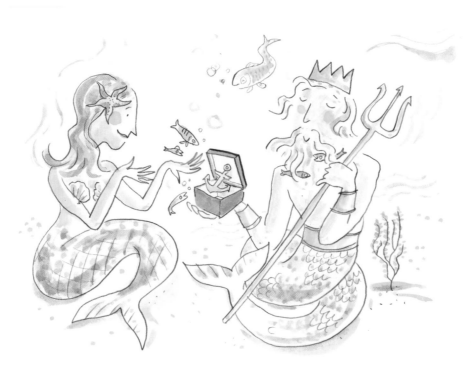

Profoundly beautiful.

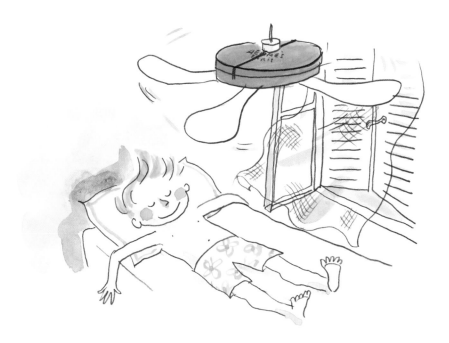

Late away summer days. Hermès- It's hot.

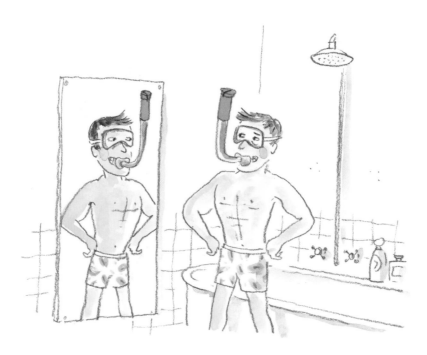

Stewart's svelte, suntanned, and set to snorkel - what a superhero!

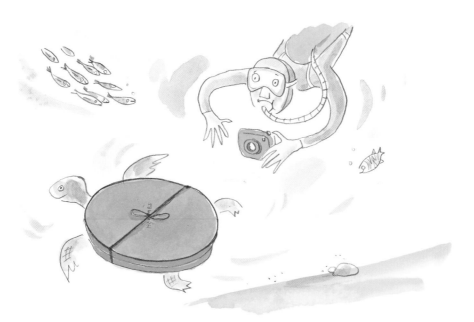

under the sea, that's where I'll be.

Seeing is believing!

orange is always flavor of the month.

Pauline's proud of Polly's progress in the pool -
She's a perfect pupil.

Pinch me, I'm seeing things.

Puts everyone else in the shade.

Sandra's sandcastles are sculptured with style this summer - Sublime!

Sasha searches for seashells on the seashore - Satisfying!

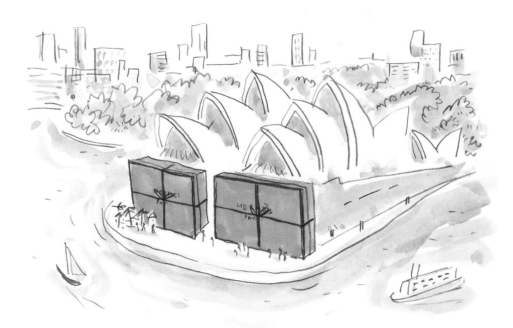

Curtains up for a great encore.

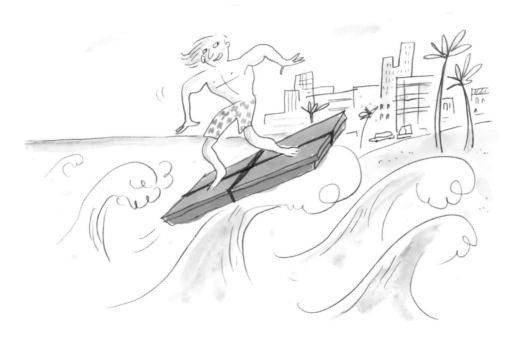

Heat wave? Surf the wave!

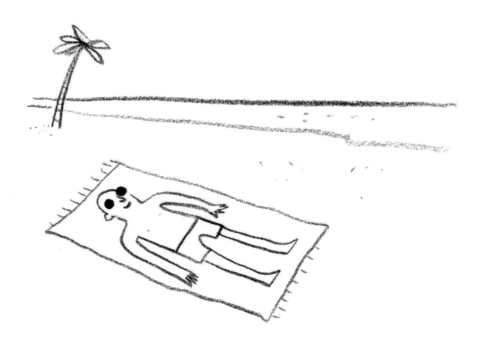

Make your mark on the beach!

Patty prefers to pass her pause
picnicking in the park - Peaceful!

Scott's serenade at sunset
left Susan smitten— Sweet!

Sunseekers strike gold strolling among shady sunflowers.

Five million star accommodation!

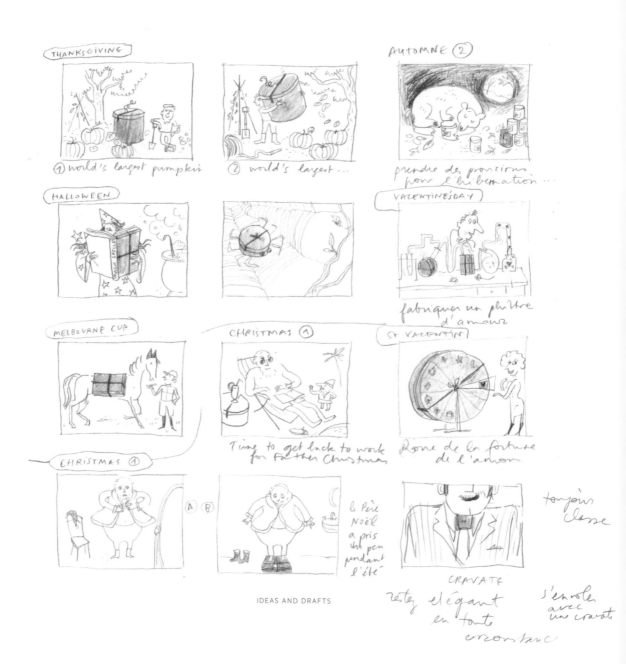

IDEAS AND DRAFTS

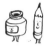

I met Alice on my first day in London, where we were both studying Illustration at Camberwell College of Arts. It is no exaggeration to say that it was a life-changing encounter. All throughout our student years we were friends, flatmates, and drawing mates. She was France's finest ambassador, adding an exotic French flavour to our daily lives. We laughed a lot, usually at our cultural differences.

During the holidays we wrote to each other, long illustrated chronicles of our daily lives from opposite sides of the Channel. After graduation, Alice headed home to Paris and later, tempted by the idea of an exotic life for myself, I followed. I was not disappointed and found my reasons to stay.

With the arrival of the new millennium, Hermès, ever innovative, along with art directors AMPM (Muriel Abecassis and Philippe Moyen), had developed an online site for the American market. By 2004, Alice had been working for the site for some time. Largely based around her drawings and using her distinctive handwriting for the text, it reflected beautifully the role of the artisan in all of Hermès's endeavours.

It was decided that it was time to develop the content of the site in general and a series of email newsletters. Hermès invited Alice to look for a work partner who could write English texts. Despite sole

proof of my writing capacities coming from our extensive correspondence, her confidence was such that she suggested me–She would draw the lines and I would write them.

Briefed by Hermès, we were to find ideas for light-hearted emails, which would raise a smile, and feel like a small, personal gift for each client. Given complete free reign, we bounced ideas around. An illustrated diary page that could be printed out and actually used? An eccentric, Hermès encyclopedia? Reading about the blatant adoration people have always had for Hermès orange boxes, which come in all manner of shapes and sizes and even boast a fan club, provided a light bulb moment. What if the boxes, so appreciated, were shown having a second life in unexpected places?

The idea took shape, and after it was made presentable by the expert hands of AMPM, it was duly accepted. At first the emails adopted the format of "101 Handy hints" as a way to present these unanticipated uses of orange boxes. Deemed superfluous, this heading was phased out by the end of the first year. The Orange Box drawings had taken on a life of their own.

There was such an amazing energy surrounding the project: we all felt a sense of personal investment and tremendous pride.

In keeping with the attention to detail for which Hermès is renowned, when the French internet site opened at the end of 2005 it was decided never to translate from the original English texts. The wordplays and jokes simply wouldn't work; each culture has its own references. AMPM took up the gauntlet for the French site and created texts filled with Gaelic wit. Every subsequent country opening a website had its own native speaker, writing in direct response to Alice's drawings.

As the project evolved over the next twelve years, so did the Internet and e-commerce department, which expanded rapidly. As technology advanced so did the emails. Finally, drawings were subtly animated, and as smart phones became more accessible, so did our work.

Working mainly by telephone, a couple of times a year Alice and I would meet up to plan the ideas for the following season's emails. They were joyous occasions—time out of our busy working and family lives, feeling as creatively free as our Camberwell days. I never tired of watching Alice translate ideas into sketches, and later seeing those pencil sketches expanded into finished pieces arrive in my inbox.

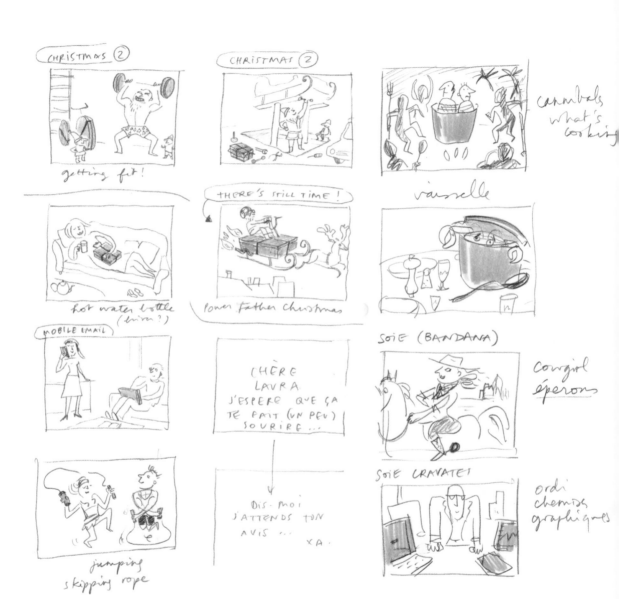

CHRISTMAS ②

getting fit!

CHRISTMAS ②

hot water bottle
(livre?)

THERE'S STILL TIME!

power Father Christmas

cannibals
what's
cooking

vaisselle

MOBILE EMAIL

CHÈRE
LAVRA.
J'ESPERE QUE ÇA
TE FAIT (UN PEU)
SOURIRE...

DIS-MOI
J'ATTENDS TON
AVIS... XA.

SOIE (BANDANA)

cowgirl
éperons

SOIE CRAVATE!

ordi
chemises
graphiques

jumping
skipping rope

GOOD AND BAD IDEAS

time to break the
tirelire pour madame

New Year's
vitamines

Australia frisbee day

Poupées russes
(collection)

Rembrandt au chapeau

fête des pères

Mother's day

Spring bench

UNIVERS HOMME

bowling

TREASURES AND FAILURES

ALICE CHARBIN

Born some years ago to an English singer mother and a French artist father, Alice Charbin was raised in the countryside and Paris and a student in London. She lives in Paris with her husband and their five children. From her atelier, she draws, works, observes, and daydreams. Mix in a year spent in India with her family, and it is these ingredients that flavour her drawings and her cooking. She has illustrated for the site *Hermes.com* for more than fifteen years. She illustrates for theatre, press, and both adult and children's publishers.

RACHAEL CANEPARI

Rachael Canepari, originally from the north of England, studied Illustration at Camberwell College of Arts, London. After graduation she moved to Paris to work for press and design agencies. Delighted to collaborate with Alice Charbin, she put her pencil to one side and picked up her quill. Together they conceived and developed the "Orange Box" project, and worked on a variety of projects for Hermès over many years. She lives in the south of France with her husband and three children.

ACKNOWLEDGEMENTS

Alice Charbin and Rachael Canepari wish to thank Hermès, first for the blessing of Jean-Louis Dumas, the big chief; Pierre-Alexis Dumas for his amused encouragement; and Axel Dumas's authorisation to publish the work in this book. Thanks are also due to archivists Anne and Caroline for their help. Thanks to Michel Campan, convinced and confident from the beginning. To AMPM, the whole tribe but especially Muriel, Philippe, Laura, and Anaelle, our creative collaborators. Thanks to Sabine, Aude, and Emmanuel at Éditions Chêne for their enthusiasm. Thanks to Prudence Dudan for her design and courage.

Alice wishes to thank Luc Charbin for his support and inspiring silhouette, recognisable in many of these drawings. To our darling children, each and everyone of them, for being them. Thanks to Rachael my copartner, letter writer, artist and so British friend. Thanks to Hazel and her attentive eye, and to Valerie Mréjen for her ingenious eye and inventive text.

Rachael wishes to thank Martin and her dear three children, so supportive and accommodating. When my mind wanders off elsewhere, my heart stays with you. To Alice Charbin for your lasting friendship and laughs along the way. To my family, who honed my sense of humour and keep it sharp.

Abrams and Éditions du Chêne would like to thank Hermès for their assistance with the production of this book, as well as for the authorization to publish it.

Illustrations copyright © 2020 Alice Charbin
Text copyright © 2020 Rachael Canepari

Originally published in France in 2019
© Hachette Livre - Éditions du Chêne

Published in 2020 by Abrams, an imprint
of ABRAMS. All rights reserved. No portion
of this book may be reproduced, stored in
a retrieval system, or transmitted in any form
or by any means, mechanical, electronic,
photocopying, recording, or otherwise, without
written permission from the publisher.

Library of Congress Control Number:
2019944404
ISBN: 978-1-4197-4527-0
Printed and bound in China: 10 9 8 7 6 5 4 3 2

Abrams books are available at special discounts
when purchased in quantity for premiums and
promotions as well as fundraising or educational
use. Special editions can also be created to
specification.
For details, contact specialsales@abramsbooks.
com or the address below.

Abrams® is a registered trademark of Harry N.
Abrams, Inc.

For the French Edition:

CEO: Emmanuel Le Vallois
Editor : Sabine Houplain and Aude Le Pichon
Graphic designer : Prudence Dudan
Production : Rémy Chauvière
Translation forewords : Katie Assef

www.editionsduchene.fr

For publication purposes, certain texts have been
adapted, and others created for a few
unpublished drawings.

ABRAMS The Art of Books
195 Broadway, New York, NY 10007
abramsbooks.com